THE DISTAN

OF ...

VOLUME I

DISCOURSE

1

Life is no more than a piquant breath in our journey through the infinity.

2

The dying light of the distant abyss distracts me from my banal life. No, no, never mind, life is not one that is thronged with clichés. Or even if it is so, adopting a position that seeks to filter and find the disqualities of my everyday experience is not one I wish to pursue.

3

What am I? if not melancholy swimming amongst the

Stars

wishing to be weightless.

Yet am dragged to the earth (in which we bear a grounded sanity),

by non-other than the clouds.

To be among the clouds

Careless…

4

The prostitution of sunlight. Ignited by the aptness of its soul yet so commonly seen as
damp.

Contempt clouds shutter us from the anxious moon; it is luxury in motion.

Brick-walled ballads cover the eyes of those who choose only to see the ineffable,

marked with the happiness of tainted rain!

4

A flower with its face to the sky and its stem steeped in the earth.

As death follows its constant betrayal

Beauty calls upon its fate.

Its petal ebbs and flows with the wind

Wonderful are those that may never be placed below our feet.

With a hurried walk towards the creases of the sun

Clouds of a mystical yellow, linger on the weighted horizon

and seagulls cut through them like twigs on melted grass.

The night's siren beckon the clouds of younger

to return home

while the emissions of the west settle

the day repeats itself.

Please appreciate its beauty.

4

Three wooden roses

Upon stagnant horizons

Dew drops from the moon

4.5

A stark breath awakens the twilight of the sea

serene discourse ensues between the fish who inhabit the waves and the fisherman who
floats

upon their home

Unaware of the soft obscenity in which the stars relish in

The stars unaware of the felicity of man

But both are proud

5

The hill of pride which bequeaths to society the tyranny of man.

The hill of pride which curtains our sight. casting a luminous shadow only for the sun to reveal its deceit.

The hill of pride, with the protagonist displayed at its peak.

He knows not of the valley?

5

The death of pride will be the birth of gratitude.

5

The altruistic self obeys no laws

The ego yearns! to be liberated

with the dry impetus that propels itself…

6

I truly do live in a beautiful world riddled with aesthetic inconsistencies as well as cruel absurdities.

7

I know nothing. At the moment, I am simply the point on an exclamation mark present in a stocky book; I wish to be the book present in an endless ever expanding library. The human condition is to be free and use this state of freedom to expand the library present in one's consciousness.

8

Glorious how the day may be!

Memento mori!

Morbidity entices the squalor of all men.

8

I am like a fish with its eyes peeled to its

tail.

Immersed in the imminent flow of its own

ridiculousness

Awaiting the springtime of its own

sanity

Alive because it realises its own

Despair.

9

What lies beyond the tree that grows with its concrete counterparts?

A jungle amongst the masses,

it expels a colour that is neither a green or a red but a solemn grey.

Imagine the imaginable.

Think the thinkable.

Never go beyond!

Beyond what?

9

The absurd places one outside the boundaries of the inner circles of society. To think different has always been disdained. I find it quite ironic to say the least. We encourage each other to adopt a rainbow of perspectives but never the perspective of that which lays beyond the many colours of said rainbow. This must be attributed to the fact that we enjoy monotony and in fact seek it with disgusting desperation.

9

The radiant glow of modernity disdains the nouveau absurd

While we trample on tear drops our satiated self befriends the sober sombreness of …

dusk.

Never accepting of all, truly infatuated by none.

10

The allure of love.

Erroneous pleasures linger on the tongues of those who speak of it;
while an astral fog descends on the frontiers of consciousness when one,
Feels it with a heavy breath!

A dance of relief engulfs those who memorise its simplicity.

A reality of dreams…
That is what makes love so seductive.

10

Or so I would assume. Truthfully, I have never felt my soul take flight and solder with another's. I wonder if I ever will, as I sit in my disquieted room. To me love is a quality that all seek, many find, but none keep. Yet, I yearn to experience it to its fullest, from the moment of realisation to the decision of its dissolution.

Tears stained. on boarded floors

Are a remembrance, of the losses of the past.

Love.

How displeasing.

Why disguise yourself from those who seek you?

11

Let those who suffer smile with the pain that has been tethered to their hearts,

A smile of pure agony shines amongst those who are drunk on ignorance.

Surely, we are all ignorant drunks.

12

Shambolic fucking!

Crazed men rape their own eyes

Birthing disowned faces.

Frowns amalgamate as grins grace their brows.

13

Impudent smoke surrounds those who crave social validation.

Isolated because of their crude smell.

In search of nothing in its absolute form.

A cherry blossom sits atop the blue mountain in all its elegance.

Charming as it is, lonely as it were.

The staccato of time burns the blossoms cracked skin.

Roots of another found embedded through its sown paths.

14

If I am truly blessed to read, why not read?

If I am truly blessed to write, why not write?

If you are truly blessed to see, why not … ?

If you are truly blessed to breathe, why not inhale the fresh air of the springs night?

If you are truly blessed to feel, why not bask in the cold embrace of the winters snow?

14

The freedom, the I thou relationship in which we share, the basic necessities one experiences in a modern utopia; these are aspects of our society which those who take shelter in a modern dystopia pray they may one day caress with the slightest touch. Well, describing the modern society as a utopia may be a slight stretch. However, we must appreciate our shortcomings and hail our failures. I say this because those who are in a position do so, are lucky.

14

Feel in every sense

The actualities of your existentialism!

Grasp the friction of silence!

And synthesise tomorrow with the same arrogance of ghostly addicts.

15

Pierce my skin with the same ubiquitous urge that you experience through

enlightenment.

We, the interstellar companions carry the weight of the stars by a branched umbrella,

revealing

the rows of the unrealised known.

15

Today, I witnessed a suicide.

The silhouette of a stranger … It stood there

before me.

And in the next moment - it snapped loose from its existence.

I just watched, invigorated.

Knowing full well what its intentions were.

I watched as if a supporter.

Its sullen attitudes removed with each twinkle of blood leaking from its heart.

Side-lined by tragedy all we can do is observe our own suicide.

15

The forever war between the sky, earth and the ephemeral in-between.

However, an interlude of peace.

Clarity returns and so too does death

A death which the I cannot know

(Only the gladness of time and the expressionless strike of the clock will

reveal another's nostalgia)

A death which supposes ecstasy

Yet,

Clarity returns and so too does life.

16

Do not walk past the lingering call of freedom;

you can hear its sanguine distractions.

Diamonds of only now never for infinity,

Pour

while they assimilate with the skin of its lure.

16

FREEDOM!

Take me now and never again.

I crave you more and more with each tedious day passing.

Quench my mindlessness with your anguish.

Fill my body with your despair.

Cuddle me with your abandonment.

17

Coddled in expressive cities, is it possible to be vacuous?

The faces of strangers are the many guises of facelessness.

They are instructed to intrigue.

17

Memorise the hue that inundates the inscrutable.

Dotted fallacies congregate in the before of the mind.

It is a barrier removed. But this should never be overcome.

17

The restoration of moonlight dissipates angst;

Primordial solitude is volatile when compared to the recreation of forgiveness.

Forget

about sanctity

17

A feeling of insane scrutiny laid upon my lungs;
There was no evidence of penetration.

It simply passed away with my breath

and rose with my release.

My being, a shaken stupor.
Two large moths war on my
Meadowed stomach!

Anxiety, nervousness, excitement are all one in the same.

18

The crown of the sky,

The jewel of the wind,

The momentary bliss of the wailing leaf faded through millennia.

Watch the reflections of paved ontology

Mask the end of youth with the bare rhetoric of…

18

Silver tongues,

embellished shine wring the ears of confused elderly.

The persuasion of youth captures the divergence of even the most stubborn.

18

The apartment of youth is taken advantage of. We cannot fathom the eeriness of the "REAL" world, they tell us, as they strive to re-enter its assembly. Them. Those who attempt intolerable control from a position undeserved. But I ask myself, if one day I will deform into their vulgarity?

Visions of reality? The real world is only true to the individual. "You don't understand the real world!" but you do not understand my reality.

19

The time being

Waterfalls hold hours, with each drop annexing a second.

The past visions of institutionalised divinity

Hedonistic pleasures.

No!

The time being.

How can you claim the irrational are capable of introspection?

Choice is in a constant chain of metamorphosis.

Cogito,

but I cannot perceive.

The time being

Crackles of leniency solidify relationships between saints.

20

Have you heard the tranquil chimes?

Its voice is the wellspring of heavenly integration.

Watch, pay close attention to your manifestation, as it is pacifically ripped from your alive corpse.

Do not fear the projection

Accept it. because this is the only choice you have.

Death to me, is the epitome of subjectivity. It is an aloof enigma, which allows the most colourless of us to fashion our own internal Basquiat. Death to me, has no end in its possibilities. How could it? Death, موت, mortem, each word presents a different opportunity of what is to come. Death to me, is all. It is heaven and hell; it is nothing; it is re-birth.

21

Frozen pillars, I say to you,

I am tired.

This is not a depression;

I am not devoid of feeling;

It is a subjugation to fatigue.

To enter the quietude of things

And rest…

Not to die and never revive.

but to feel rejuvenated with the unjustified energy I should have.

Where have you gone?

Without you I cannot even own a crippled smile.

22

The stillness of the lake with its gentle ripples, sends me to peace.

But the child that weeps with the chrysanthemum

Shock!

Drowned in casted dirt, is chaos' memorial.

22

Inertia is perfection

Both the same

Both unattainable

Framed in a static ether. I am motionless. Yet ever-morphing.

23

A frustrated, comic of emotions

a slight elation but do not mistake it for pleasure;

my body, the provider of an inexplicable

Density.

I am familiar, with the source of this asymmetry.

I know her well;

There's nothing I can do to rid of her.

Because there is nothing I can do to castle her

24

Art is the true foundation of a society. Whether this be through the captivation of music, the riddles of a poem, or the directness of a painting; all ignite the seed which blossoms into innovative intentions.

Art progresses past the margins of moderation. To be exceptionally moderate has found its way to the vanguard of societal praise, protecting us from the absurd. "Reach for the skies, never mind that, I tell you reach for the stars." How ill-conceived are these notions. The man telling you to limit your ambition at the sky is no different to the women who tells you to strive that little bit further to reach the limit of the stars. Either way, by these convictions once our destination has been decided we concede ourselves to the gratification of their restrictions.

Reach and keep reaching to nowhere, to nothing, until death requires you to reach no more. Only then do you provide yourself with the adequate context for undisputed growth.

25

The branches of a tree captured on the canvas of the overcast sky

Are now fields of disregarded tulips

I am sitting at the back of the house.

"Are you enjoying yourself?"

It's lovely.

How nice it is to be happy. Warm and beautiful.

26

Red roses soil our plugged instincts and brighten gauche floors
Suffocating under billows, the stringent darkness arrives early.
Sunsets are tempting but are possessed by the long night.

How long it is!
Unifying humanity in its depressed sanctuary.
Its sermons,
as they preach to unnoticed stars, are imbued with despondency.

27

A journey full of experience? Is this how you would simplify the intricacies of life?

Full of experience!

Tell me, what have you seen with the eyes that you have been blessed with.

Tell me, if you have been grateful for your failures.

What experience?

Our subjective selves can only hold opinions on so little

Our subjective siblings are the same.

Is heaven full of what is. Or what ought to be.

Full of what is good. Don't be so childish.

28

I ask you kindly to gouge out your vessels and blow away the false smog of defiled knives.

You who has…

What do you have?

Material? Morality? Virtue?

What you have is nothing.

The porcelain act, full of monotonous chapters, breaks with a splash of vibrancy.

What does it matter?

Does happiness flutter its feathers because of you?

What matters, is that it does not.

Your action is equivalent to the grain of sand which ever so softly carves its remnants into the rocky beach. An important statement for the sand and the rock, but effortlessly forgotten by the water.

Do not take this as an excuse to wallow in inaction.

29

The nectar of connection adjudicates dusty companionship. We who share smiles with those who have formed a nectar similar to ours, share smiles worth crystal rivers and escapades that are more copious … than the floating cosmos. In these moments we are innocent. A blissful innocence. A blissful peace. We meet a reversal of time where we once again transcend into our past selves. So happy and so excited, is it possible to recreate these moments without being mindless of the functions and levers of the mechanical city? or the fragmented country? or our polarised existence?

And just hug the cushioned cacophony. A smile becomes a laugh of solace.

30

I am lost on the plateau of constraint.

stumbling.

The claustrophobic daydream surrounding me never ceases.

Gnawing for help but I cannot ask. I am seen as the anchor for others.

I cannot rust!

but I have already withered…

30

What an amazing sight it would be to waltz with the moon's heart.

Instead we are stuck;

Shoved into houses we call our homes.

If my home is where my heart is …

Does that mean I am homeless …

If I have not found my heart?

A homeless, heartless man seeking warmth wherever it may pour.

31

Dreams forged in the pantheon invite gods to imitate their perfection.

Exactly without fault because dreams digress from our cosmology.

Dreams are established in a realm we wish to live; it is our individual heaven.

Cast your consciousness to the sleeping day and describe it.

You cannot.

How does a day sleep?

How does the night wake?

It is the apprehensions of our dormant contemplation that attend the lectures of dreams,

in order to piece our experience into a non-unified puzzle.

Dreams are a pasture where experiences collide and puncture the paste of our familiar

natural laws.

A positive sum game between your standards and your subconsciousness.

Thank You.

Lightning Source UK Ltd.
Milton Keynes UK
UKHW011016150421
382040UK00002B/255